MW00584325

HER OWN THOUGHTS AND REFLECTIONS WERE HABITUALLY HER BEST COMPANIONS.

— JANE AUSTEN —

THIS JOURNAL BELONGS TO

WHICH OF ALL
MY IMPORTANT
NOTHINGS
SHALL I TELL
YOU FIRST?

**BUT INDEED
I WOULD RATHER
HAVE NOTHING
BUT TEA.**

IF ADVENTURES
WILL NOT BEFALL
A YOUNG LADY IN
HER OWN VILLAGE,
SHE MUST SEEK
THEM ABROAD.

EVERY NEIGHBORHOOD SHOULD HAVE A GREAT LADY.

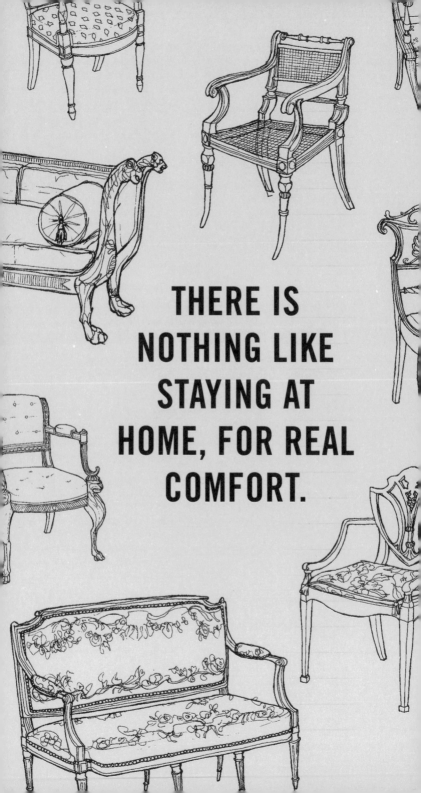

THERE IS NOTHING LIKE STAYING AT HOME, FOR REAL COMFORT.

THERE ARE
AS MANY
FORMS OF LOVE
AS THERE
ARE MOMENTS
IN TIME.

**FOR WHAT
DO WE LIVE,
BUT TO MAKE
SPORT FOR
OUR NEIGHBORS,
AND LAUGH
AT THEM IN
OUR TURN?**

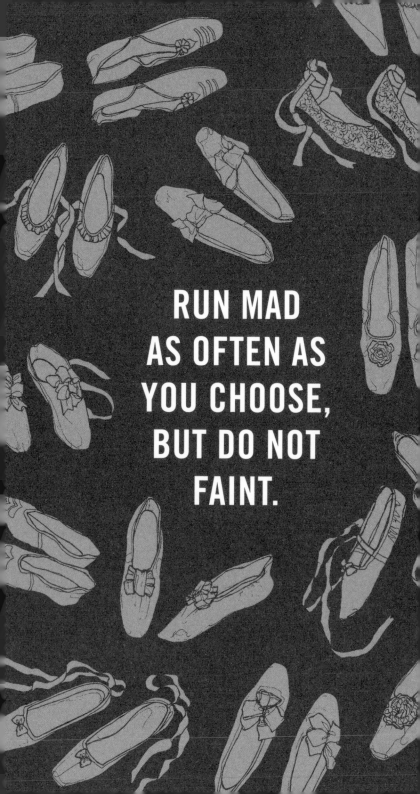

RUN MAD
AS OFTEN AS
YOU CHOOSE,
BUT DO NOT
FAINT.

WHAT ARE MEN TO ROCKS AND MOUNTAINS?

WE NONE OF US
EXPECT TO BE IN
SMOOTH WATER
ALL OUR DAYS.

ONE CAN NEVER
HAVE TOO LARGE
A PARTY.

INDULGE YOUR
IMAGINATION IN
EVERY POSSIBLE
FLIGHT.

**THERE COULD
HAVE BEEN NO
TWO HEARTS
SO OPEN,
NO TASTES
SO SIMILAR,
NO FEELINGS SO
IN UNISON.**

NOBODY MINDS HAVING WHAT IS TOO GOOD FOR THEM.

I AM ALL
ASTONISHMENT.

WITHOUT MUSIC,
LIFE WOULD BE
A BLANK TO ME.

PERHAPS
IT IS OUR
IMPERFECTIONS
THAT MAKE US
SO PERFECT FOR
ONE ANOTHER!

ONE MAN'S
STYLE MUST NOT
BE THE RULE
OF ANOTHER'S.

A WATCH
IS ALWAYS
TOO FAST OR
TOO SLOW.
I CANNOT BE
DICTATED TO
BY A WATCH.

IT ISN'T WHAT WE
SAY OR THINK THAT
DEFINES US, BUT
WHAT WE DO.

Design by Celina Carvalho
Illustration by Anita Rundles

ISBN 978-1-4197-2769-6

© 2017 Abrams Noterie

Printed and bound in China
10 9 8 7 6 5 4 3 2 1

Abrams Noterie products are available at special discounts when purchased in quantity for premiums and promotions as well as fundraising or educational use. Special editions can also be created to specification. For details, contact specialsales@abramsbooks.com or the address below.

ABRAMS The Art of Books
115 West 18th Street, New York, NY 10011
abramsbooks.com